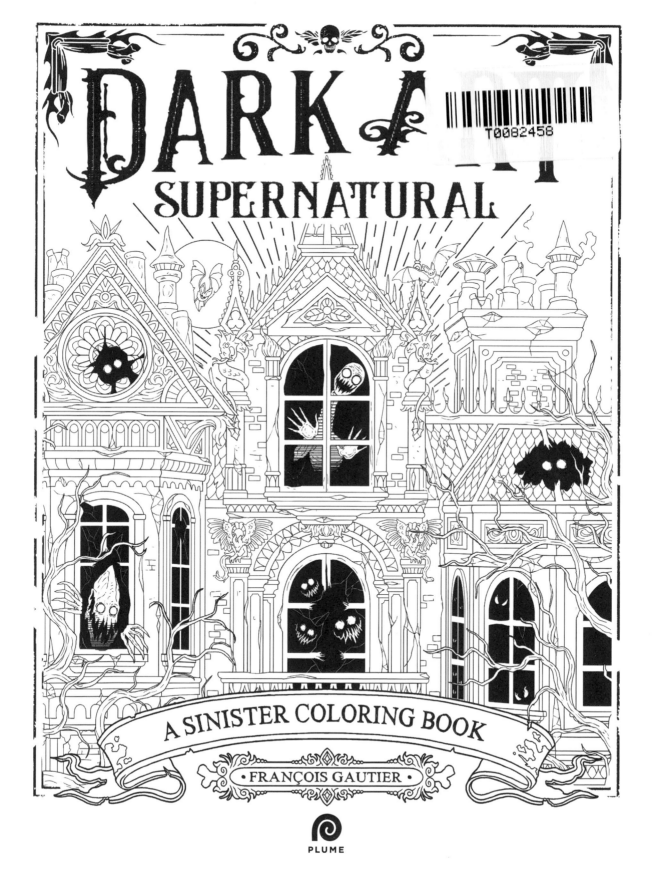

DARK ART
SUPERNATURAL

A SINISTER COLORING BOOK

· FRANÇOIS GAUTIER ·

PLUME

Illustrated by
François Gautier

Edited by
Lara Murphy

Designed by
Jade Moore

Cover design by
John Bigwood and Jake Da'Costa

Colored by

...

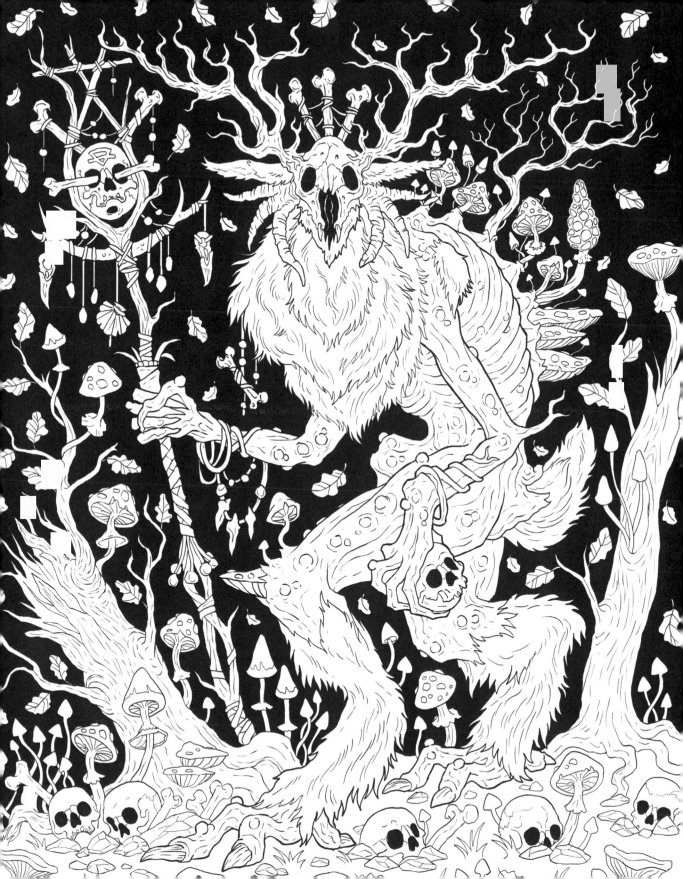

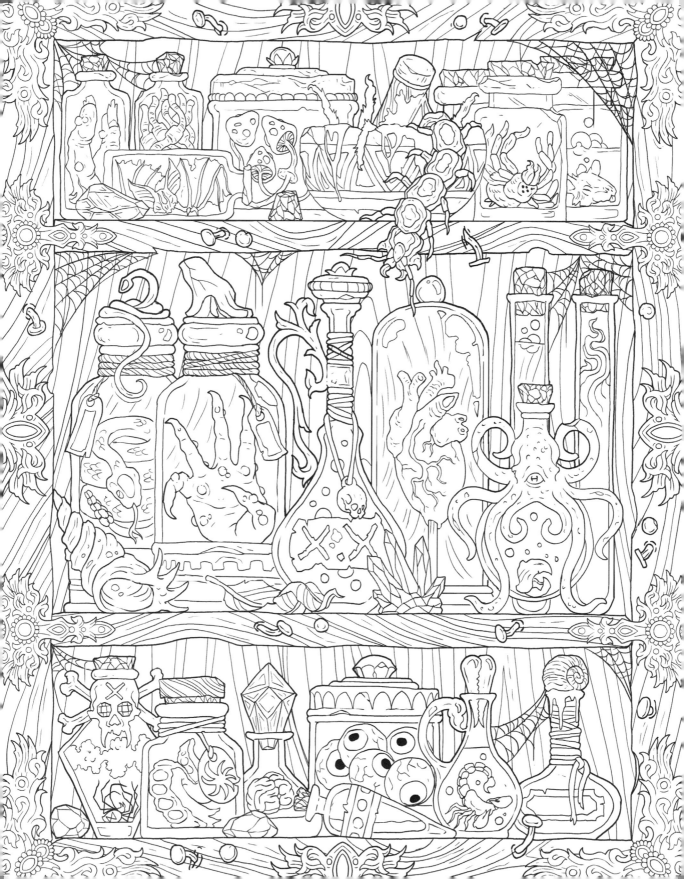

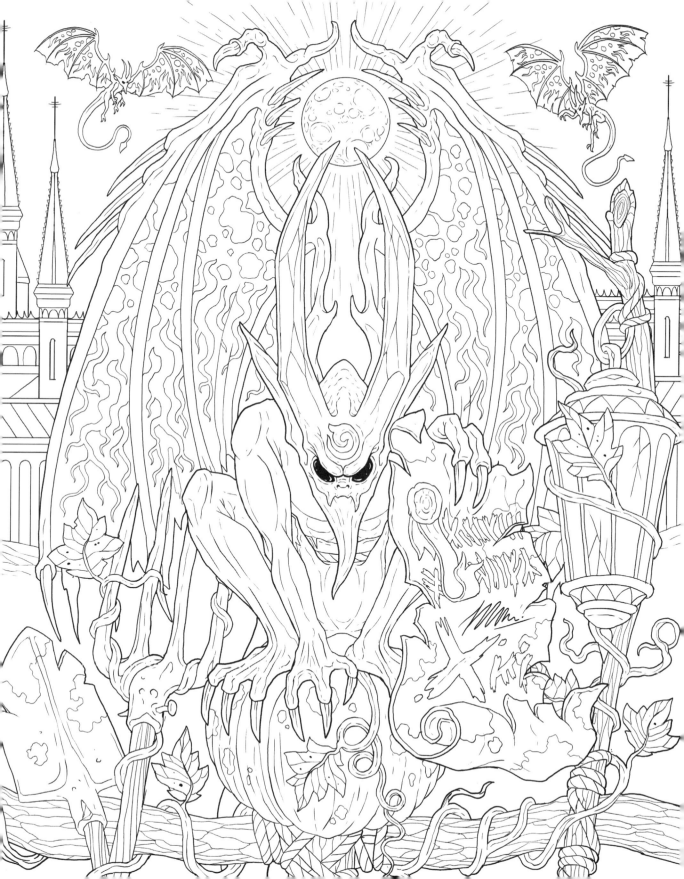

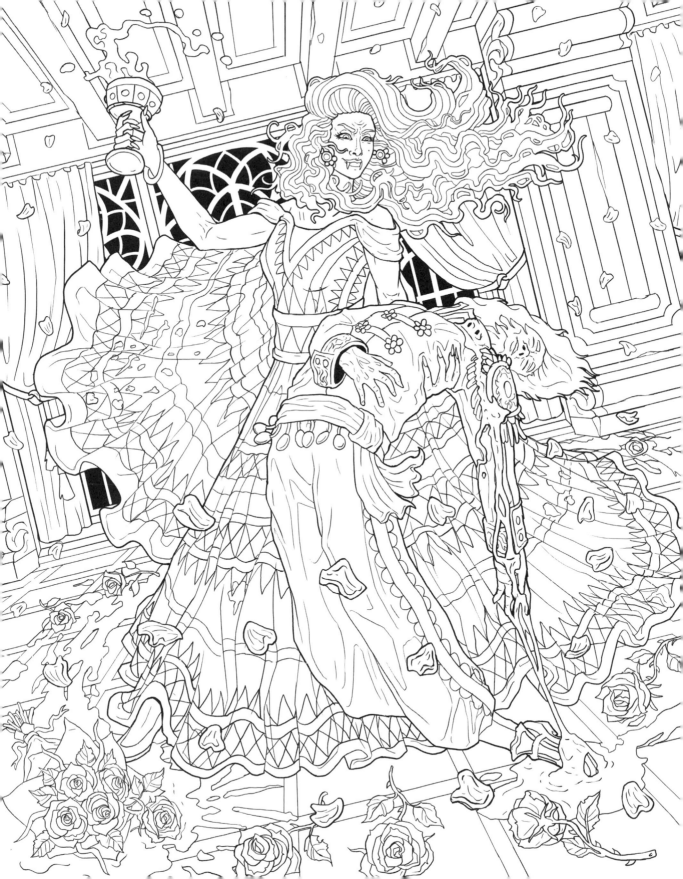

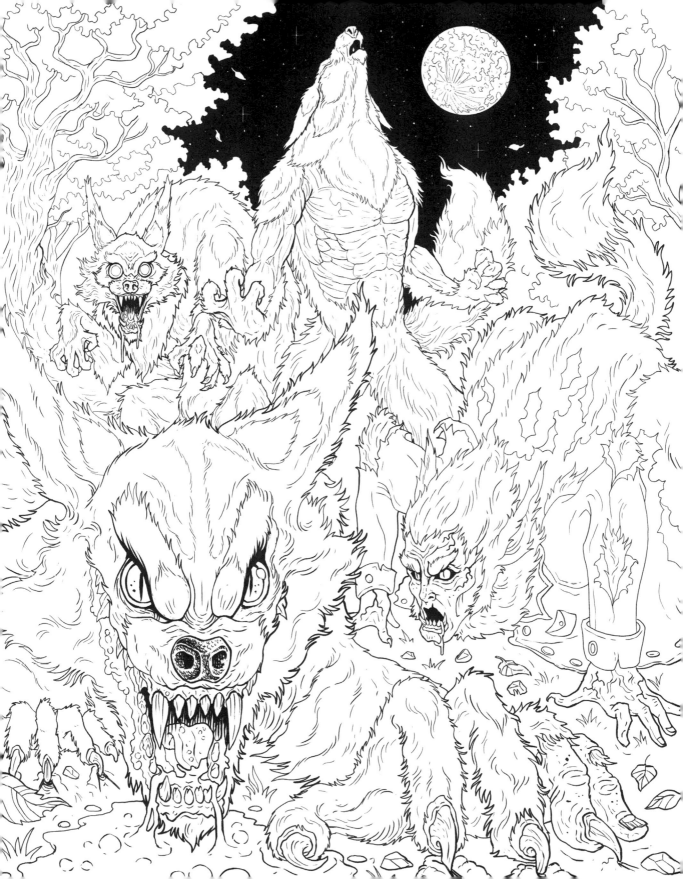

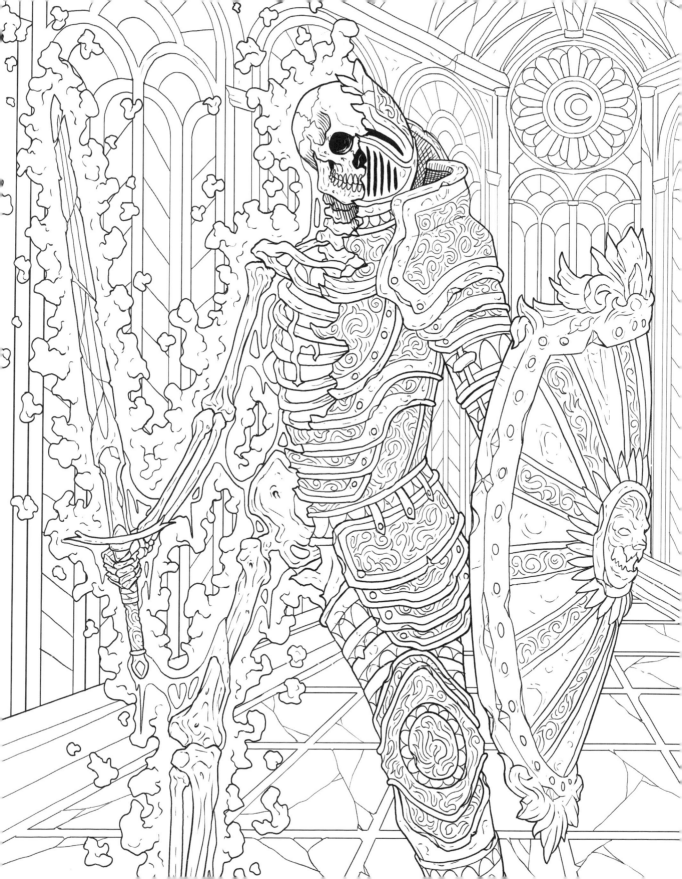

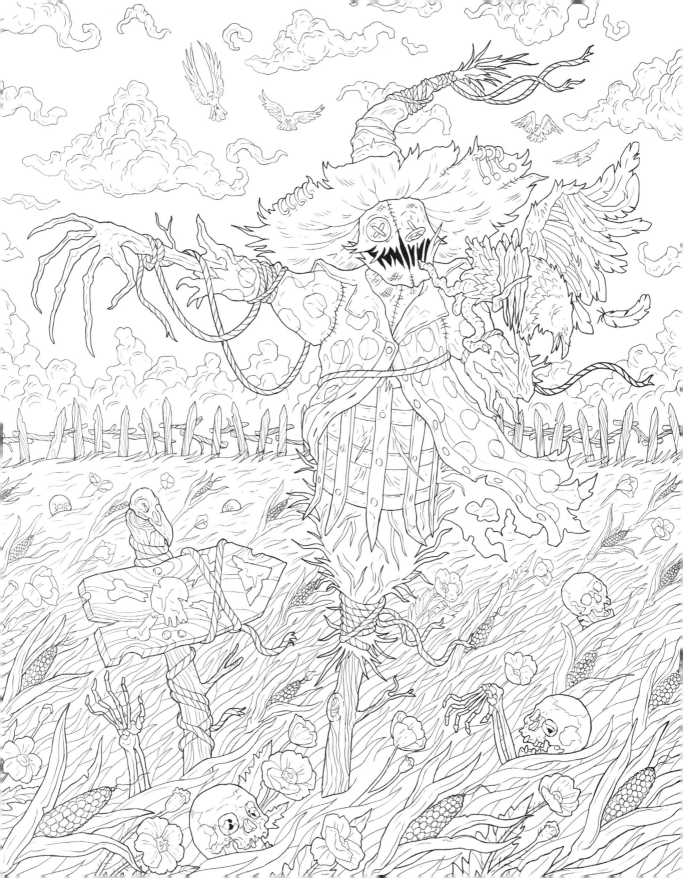

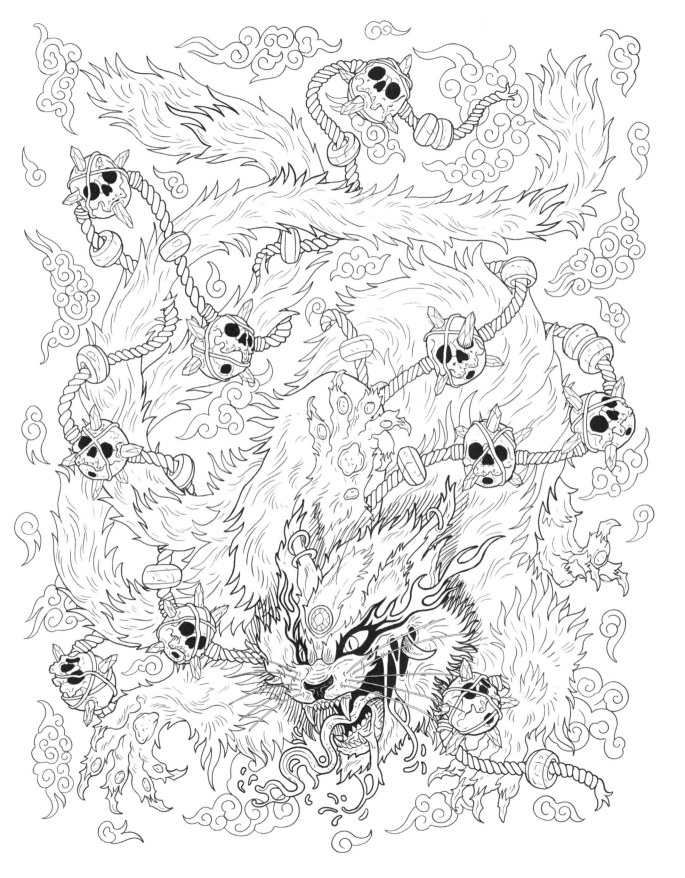

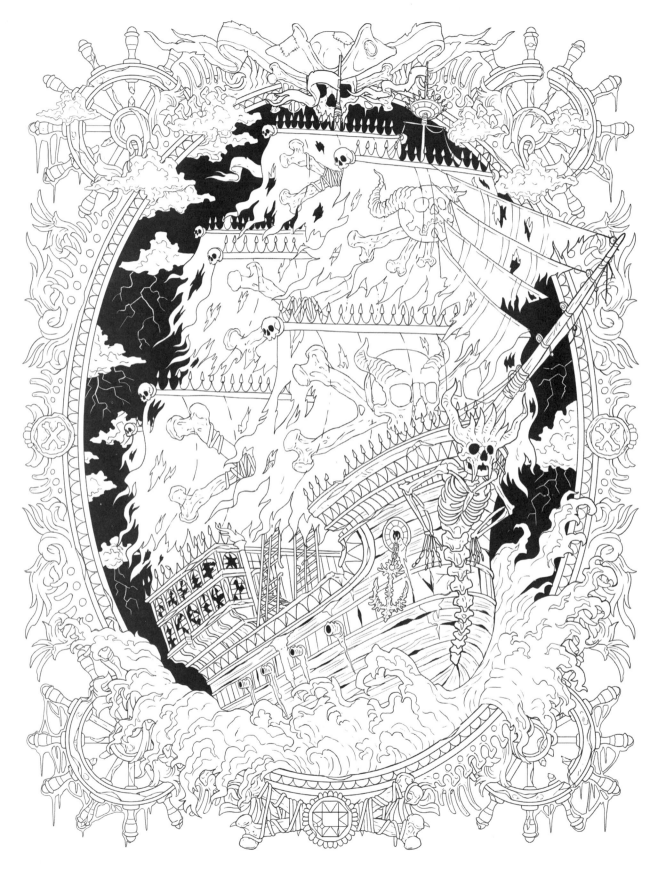

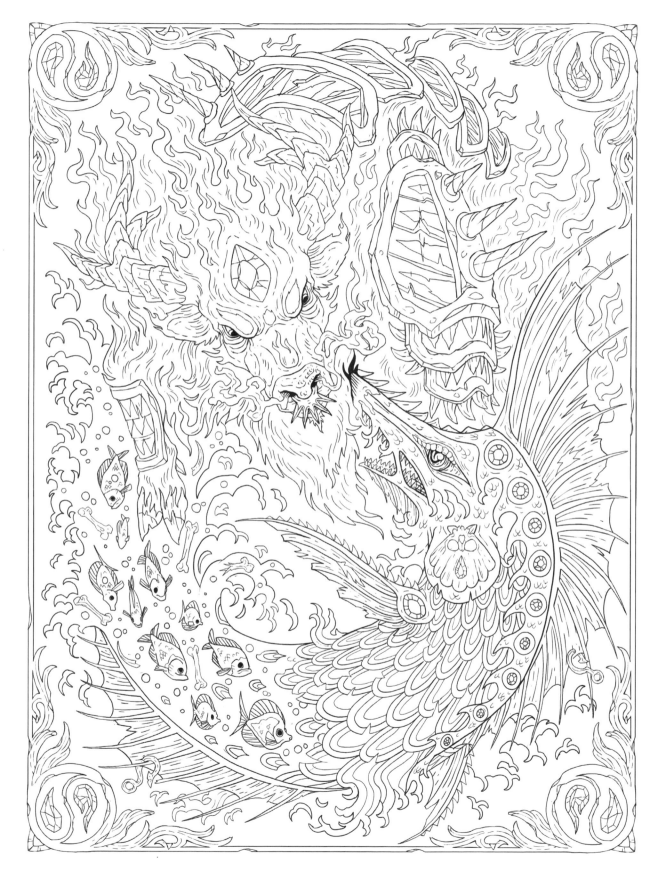

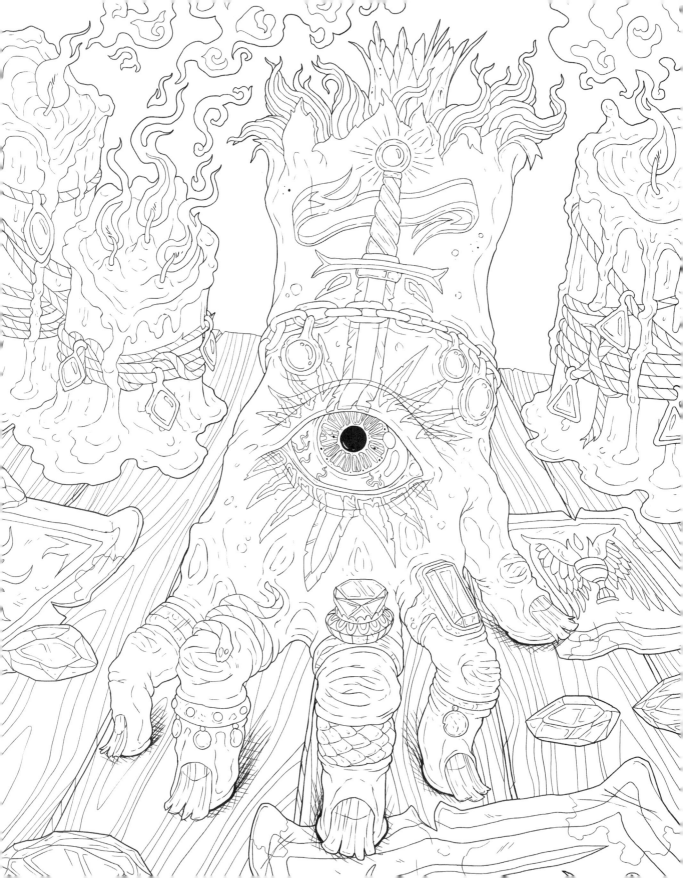

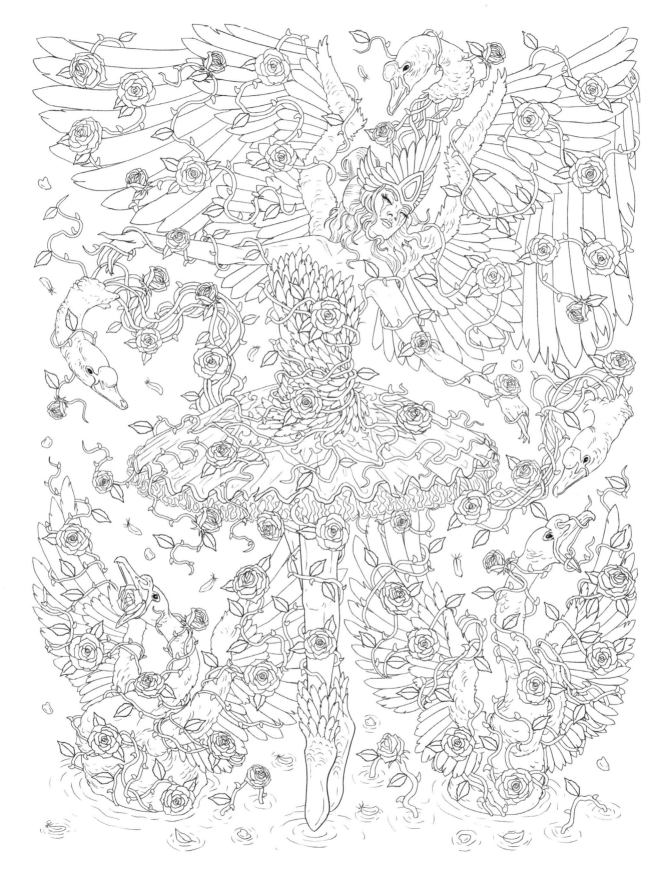

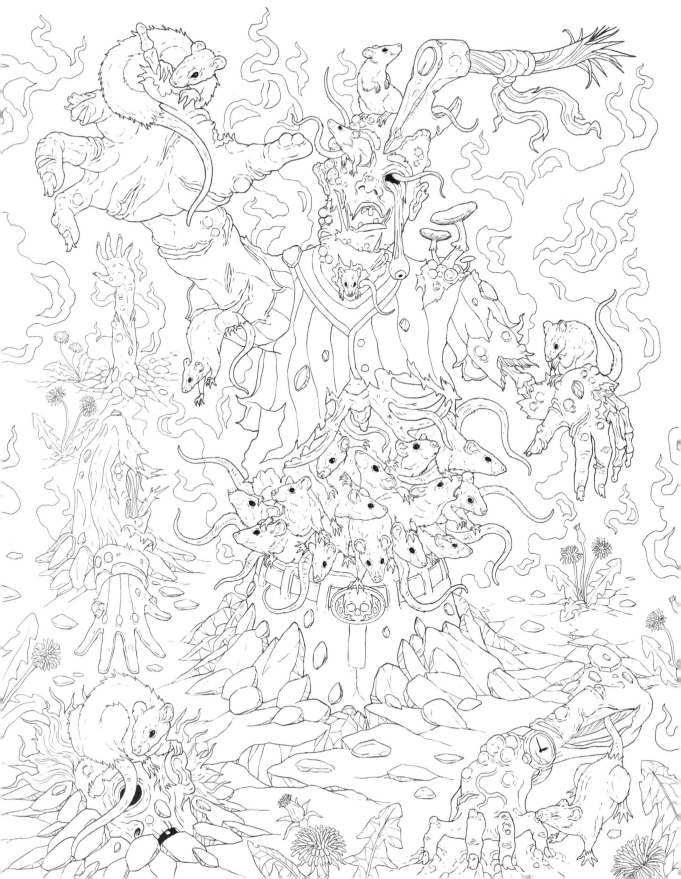

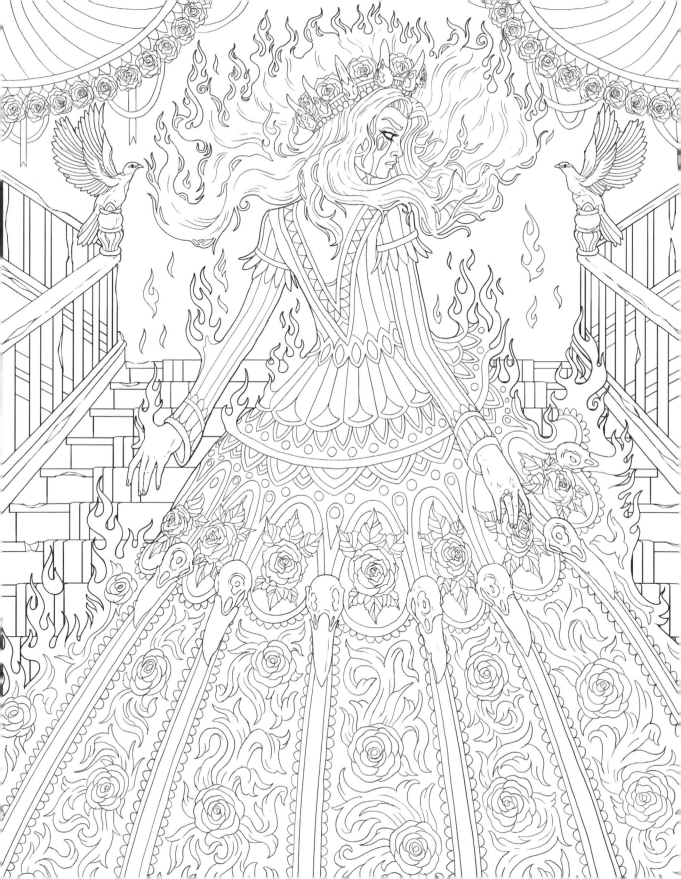

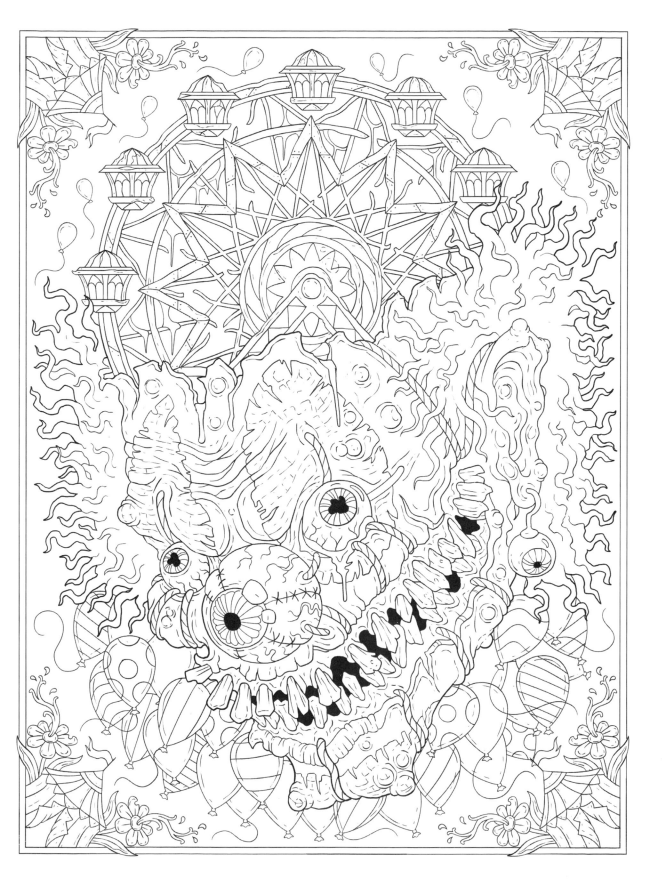

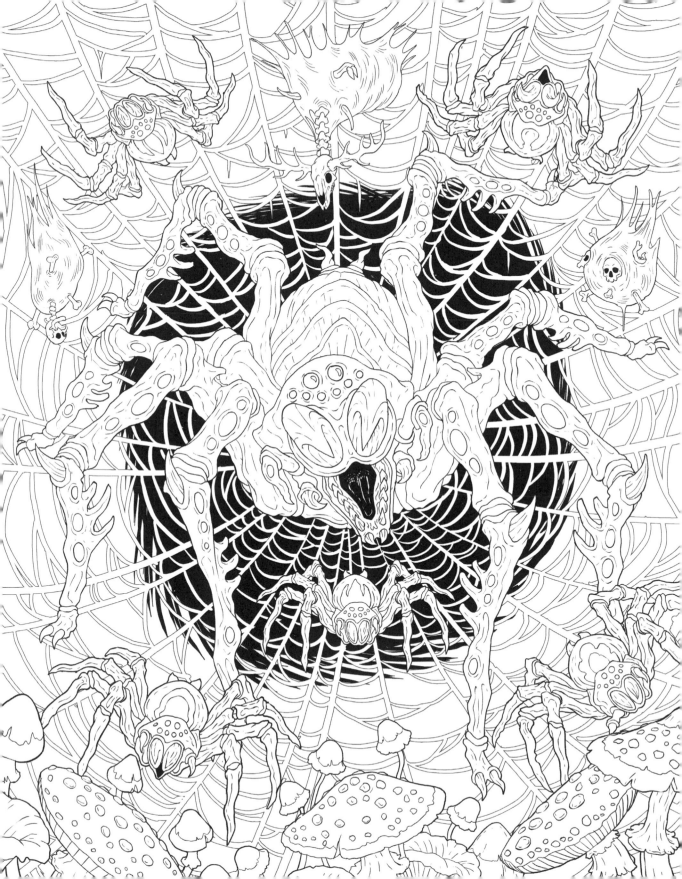

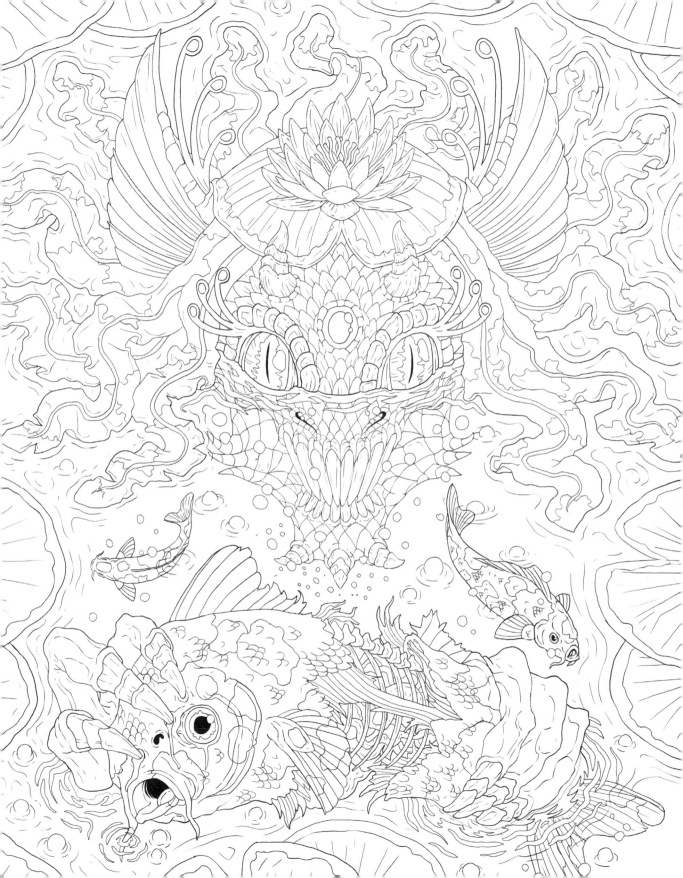

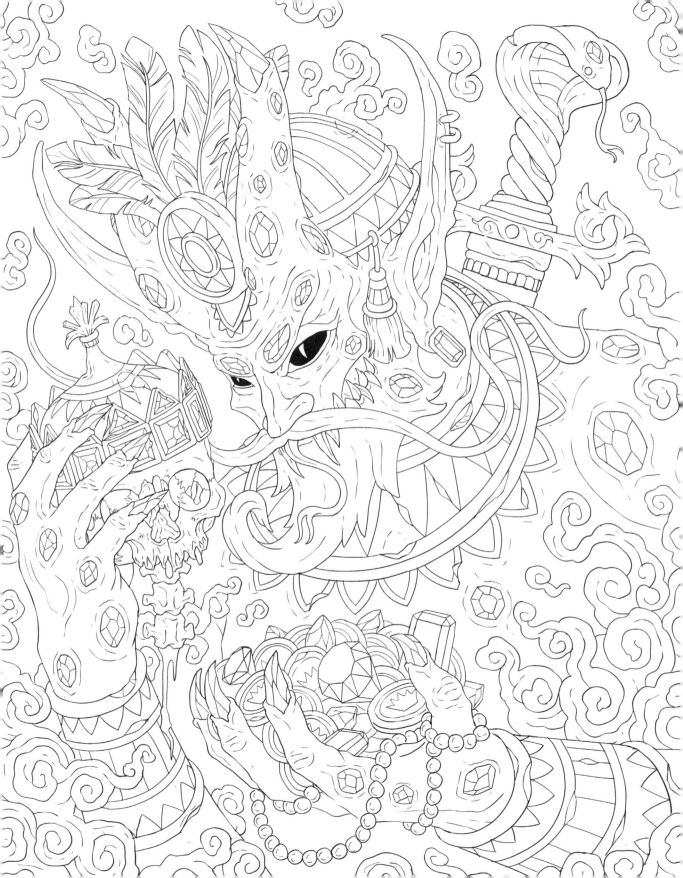

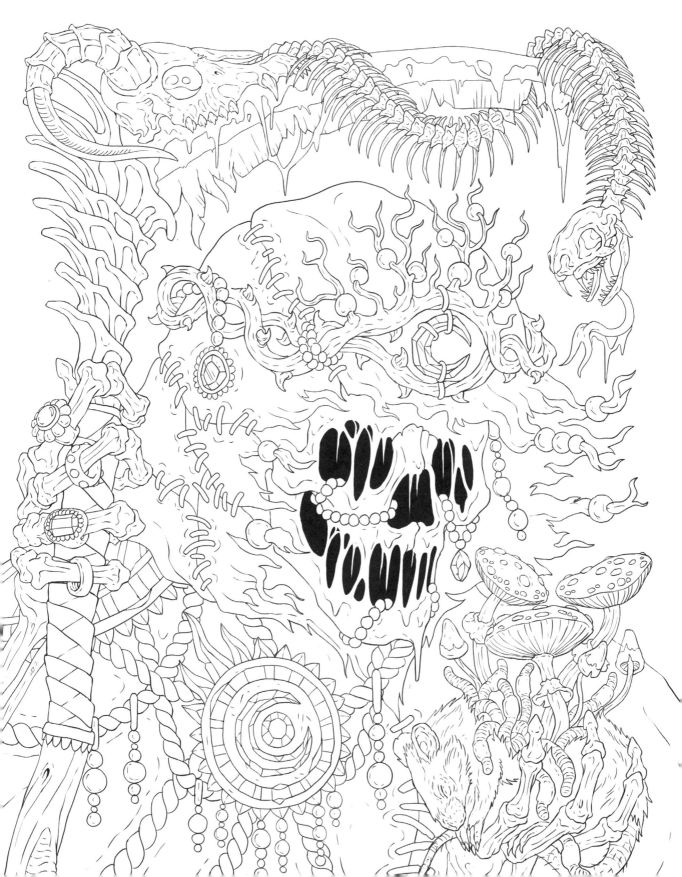

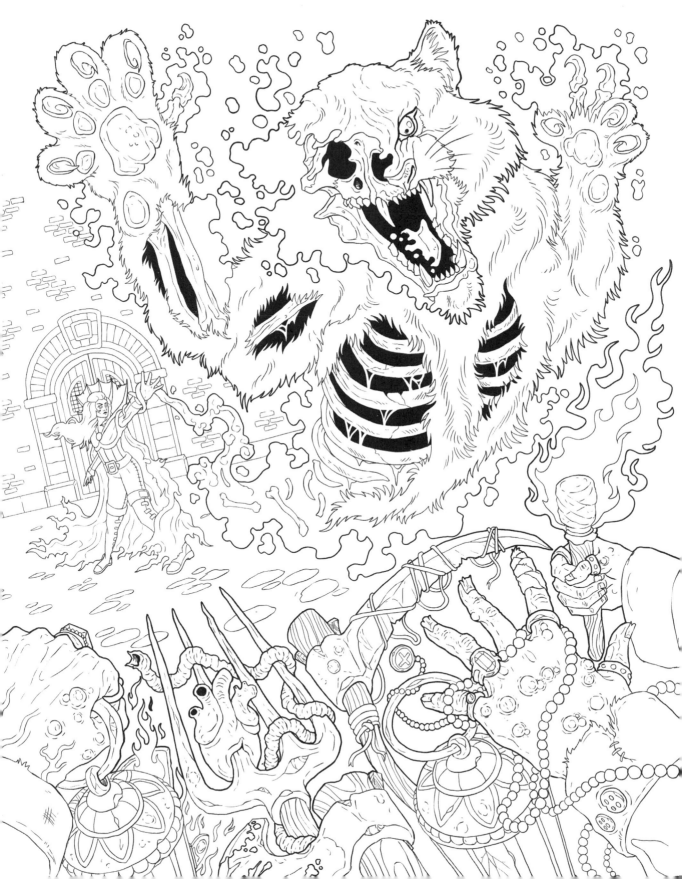

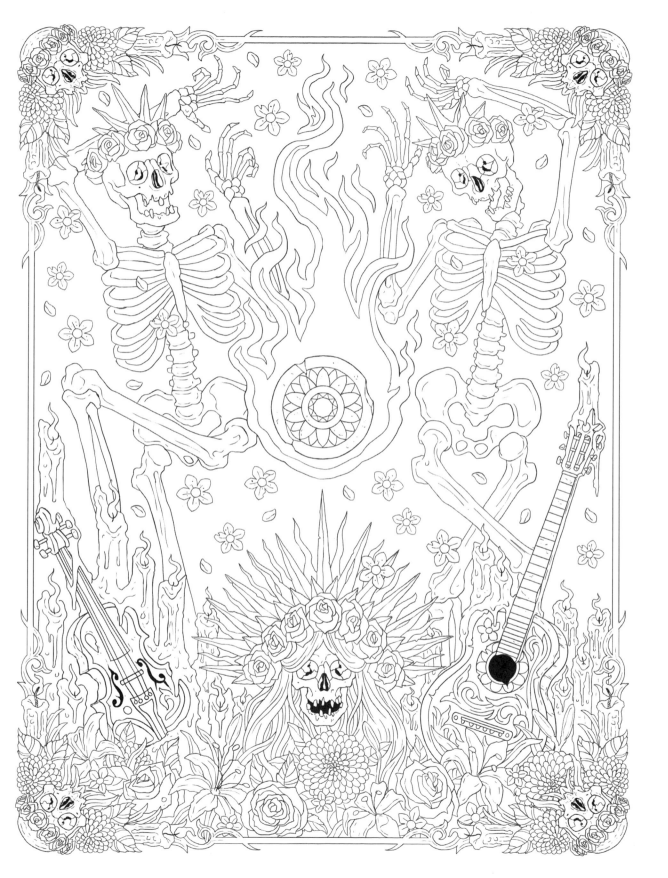

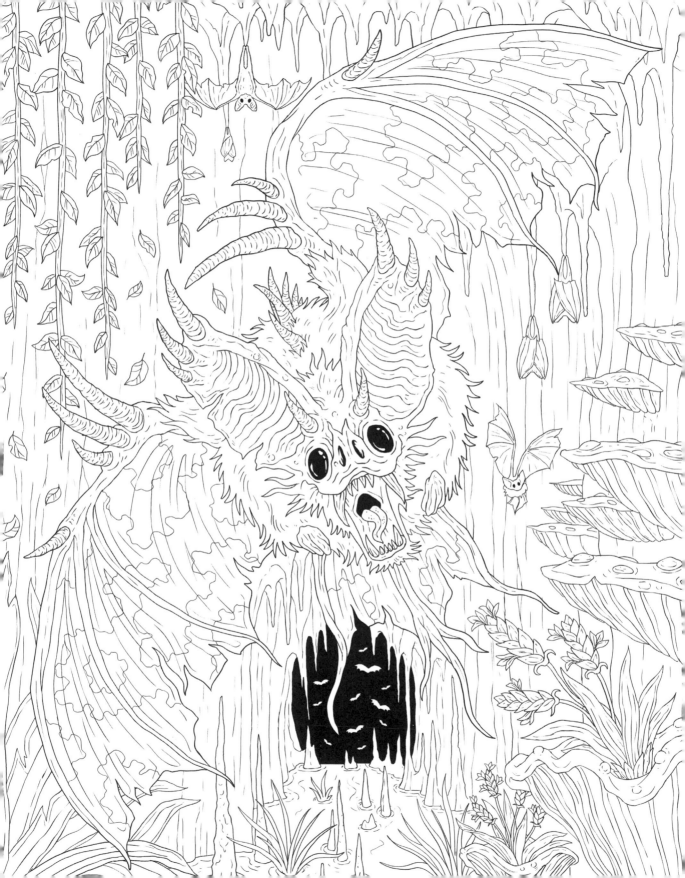

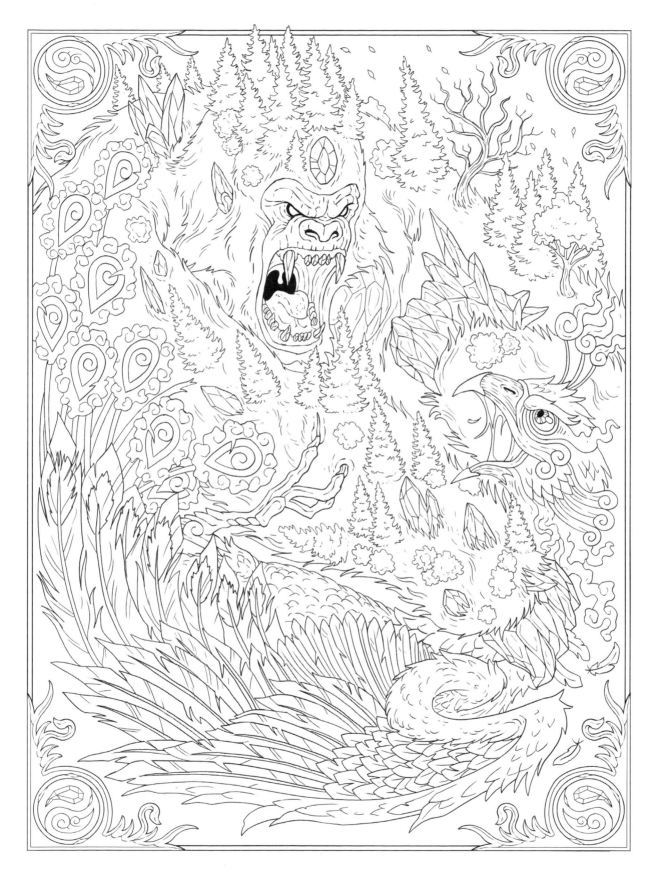

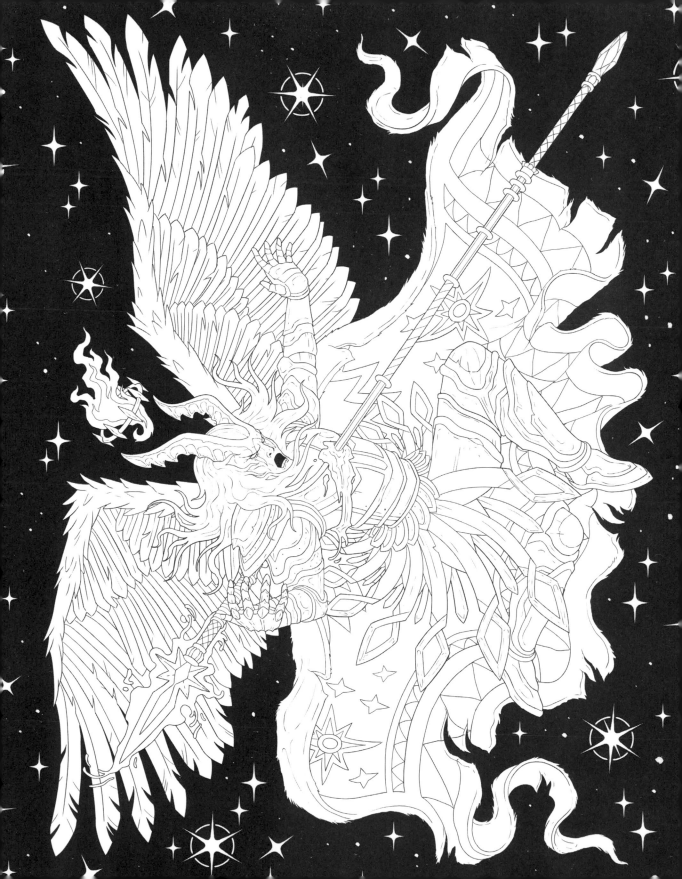

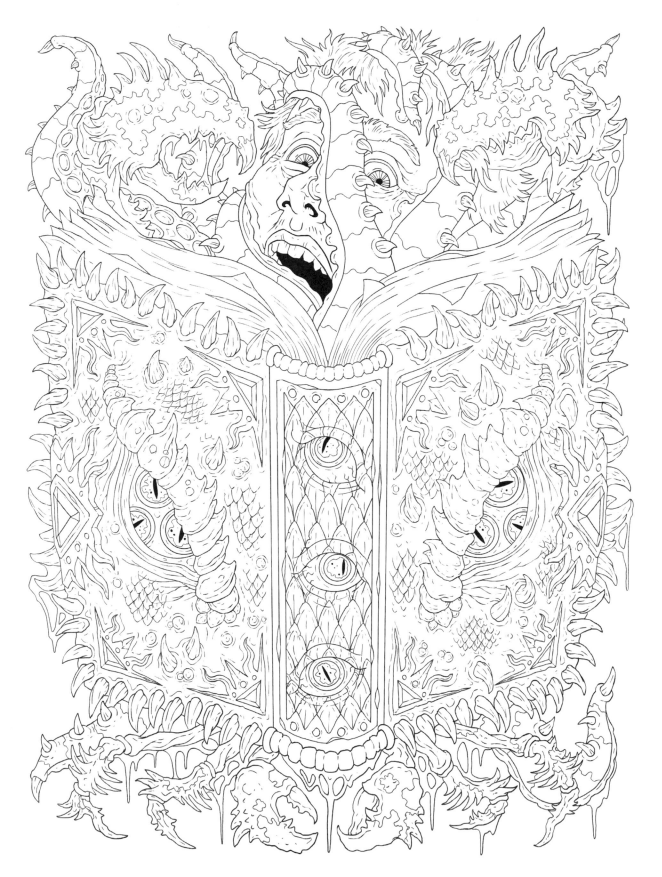

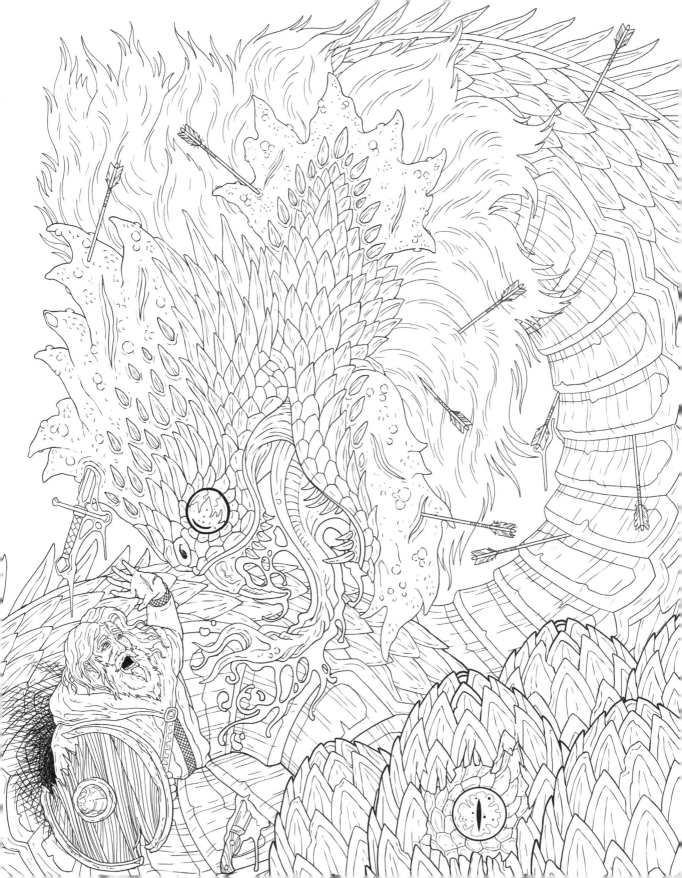

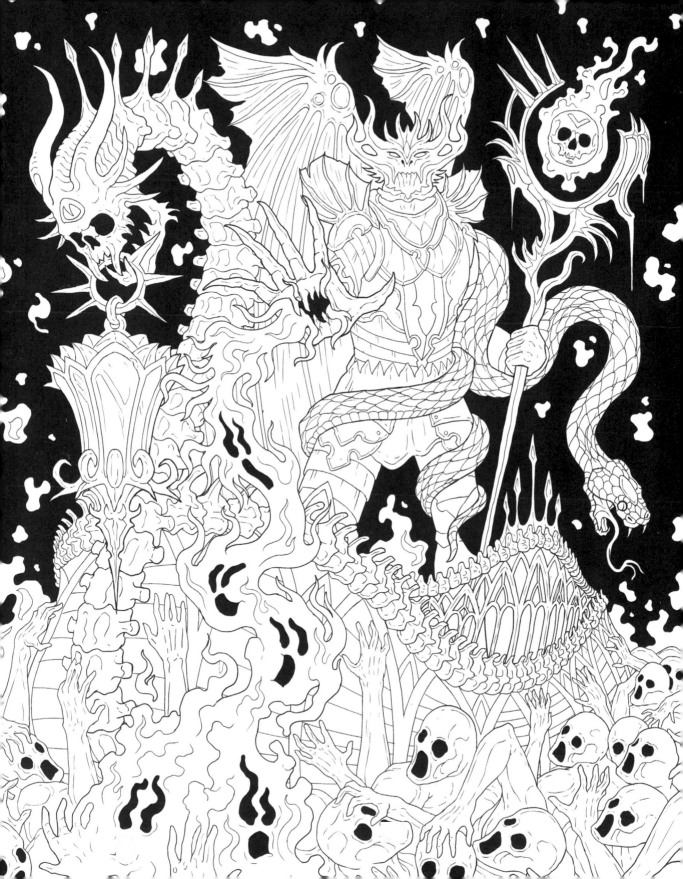

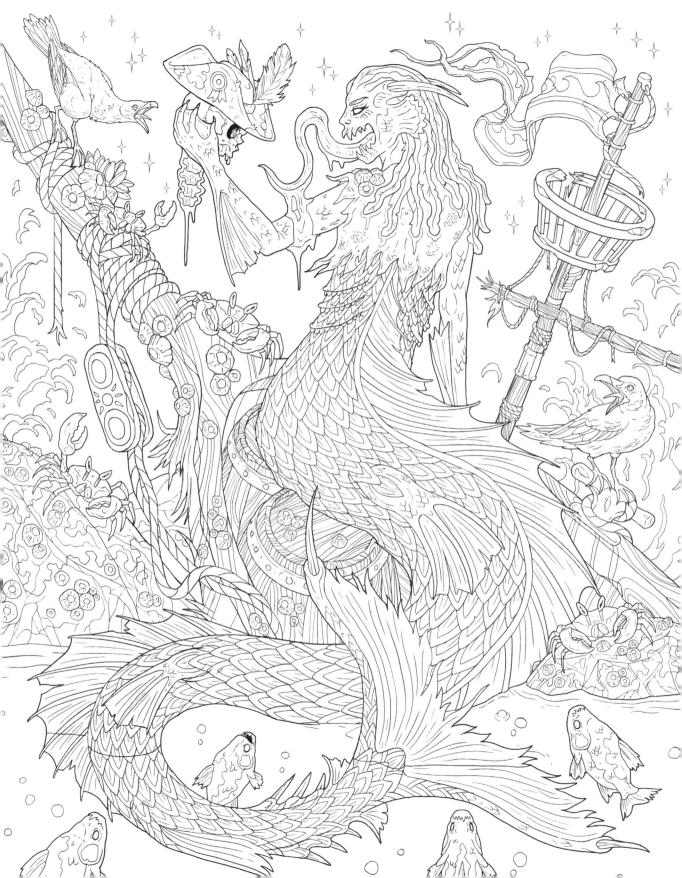

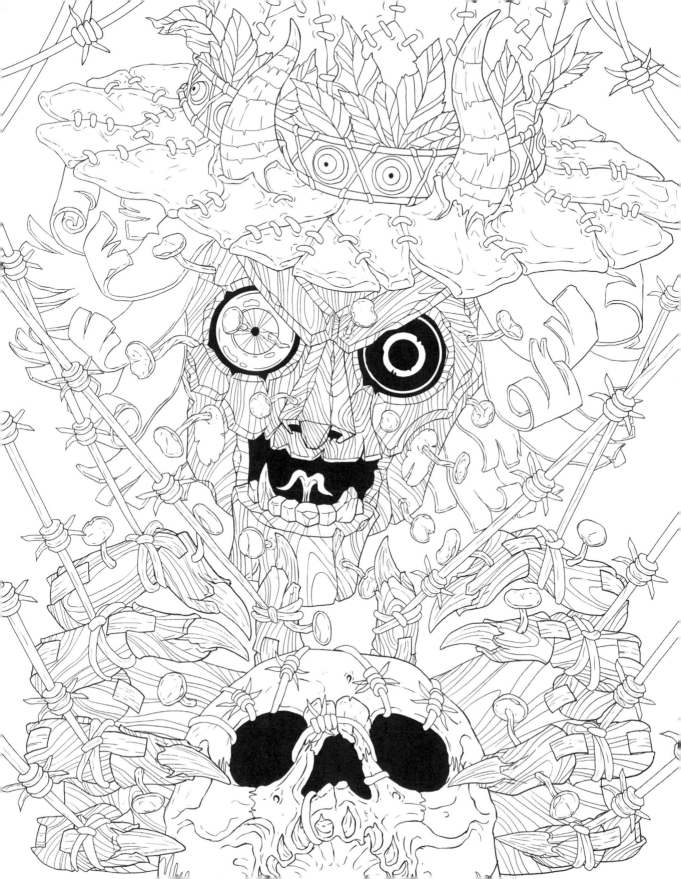

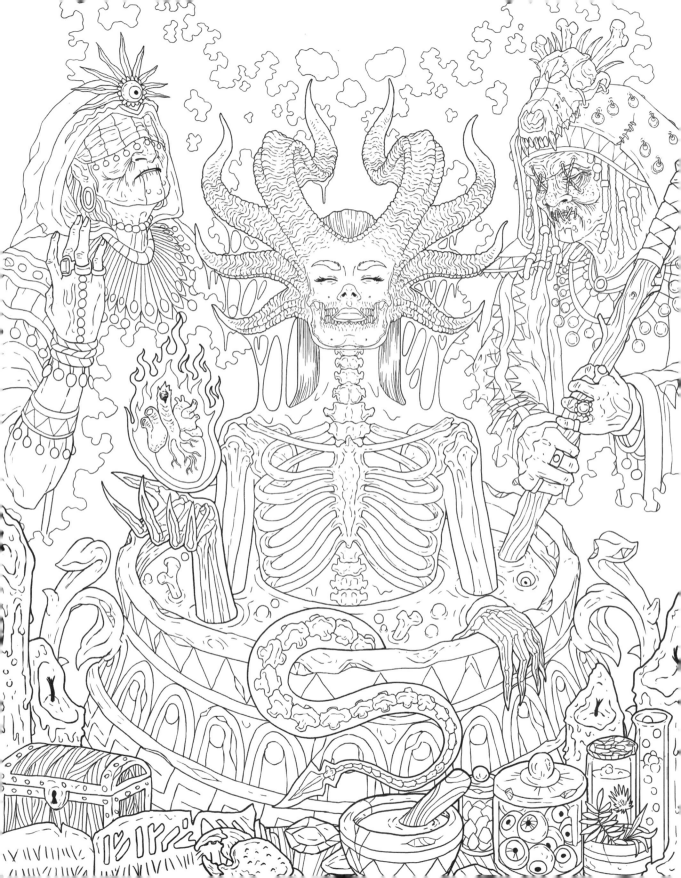

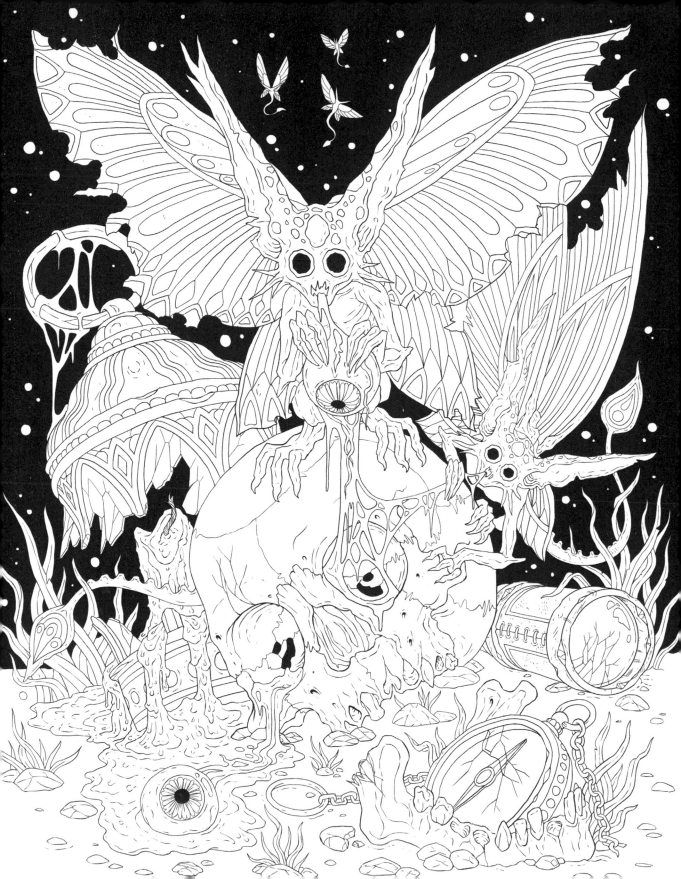

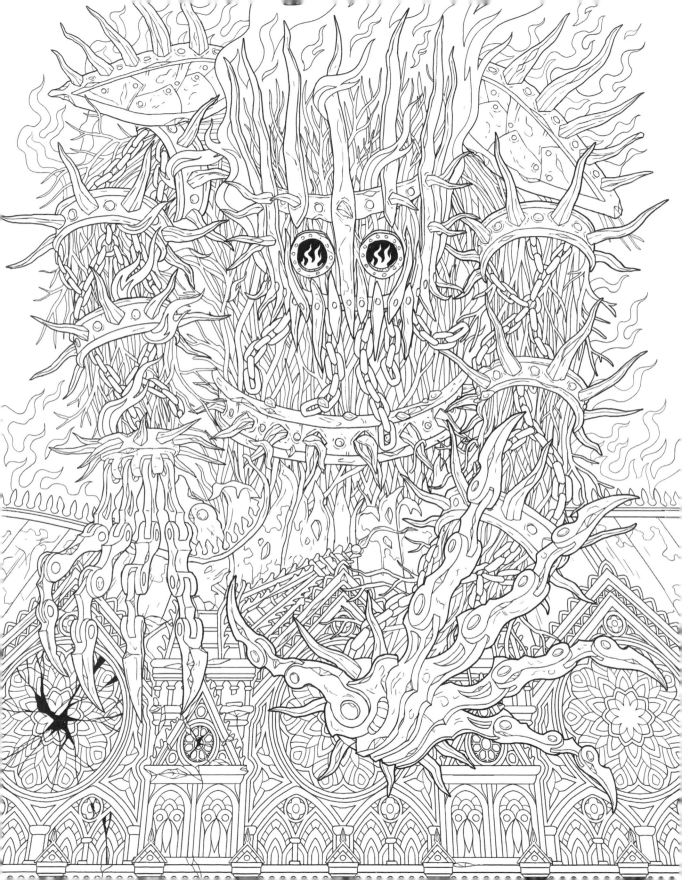

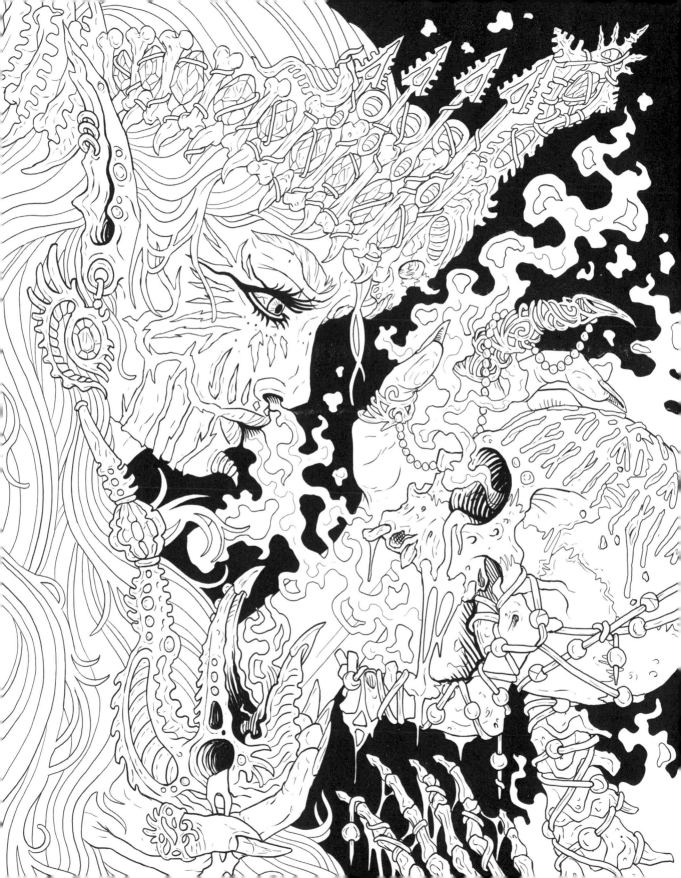

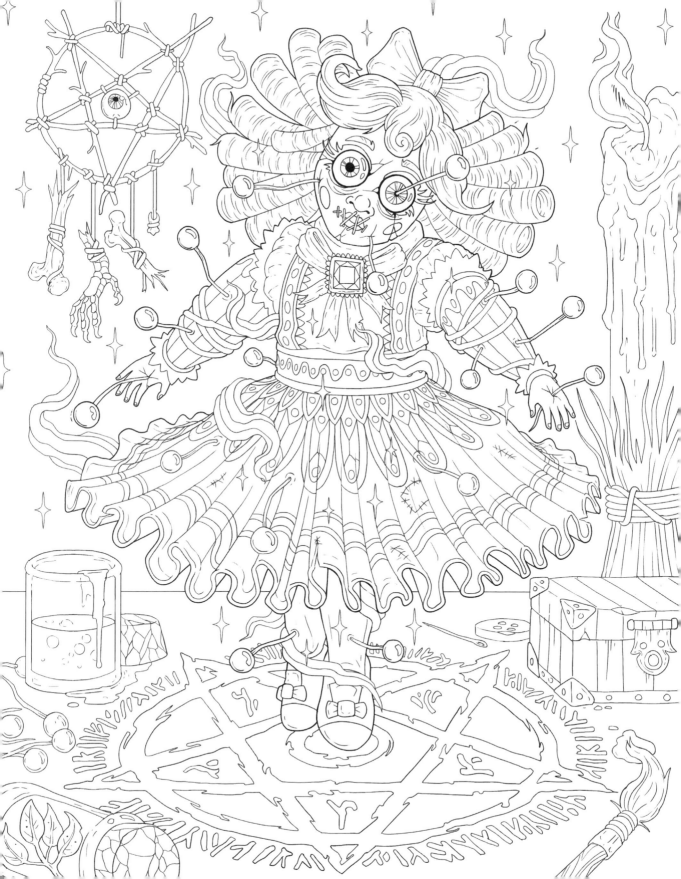

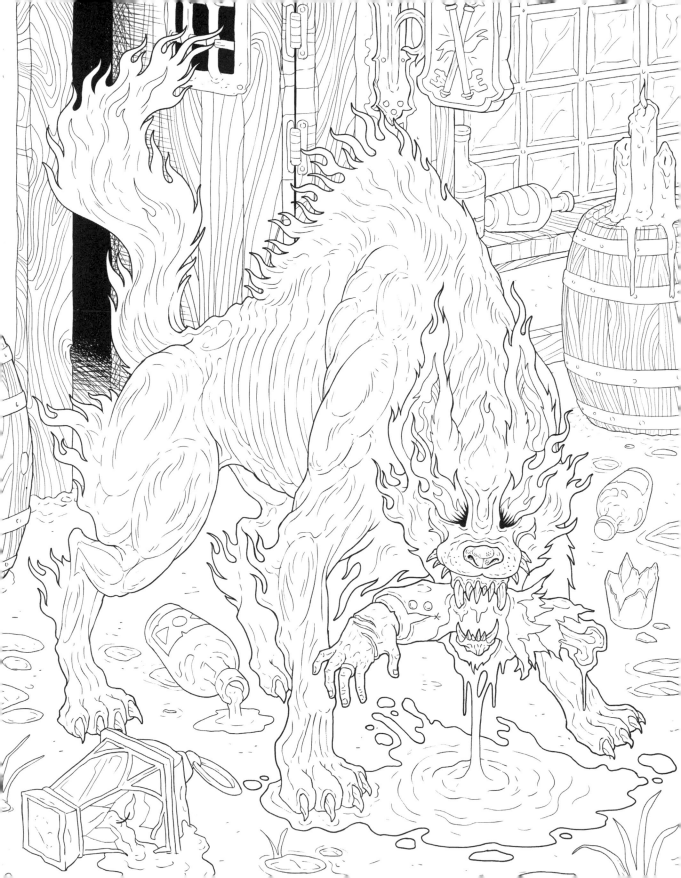

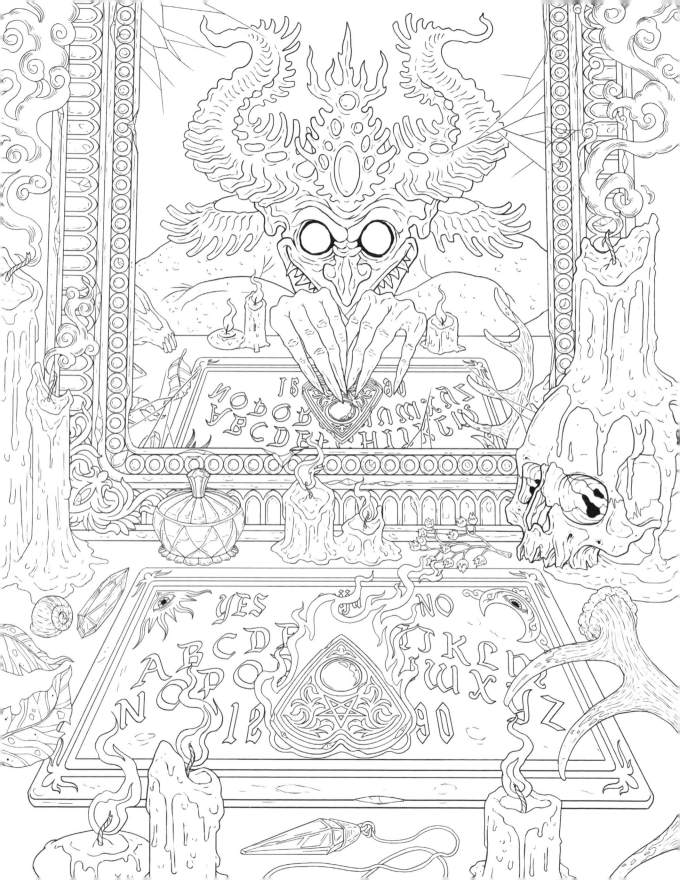

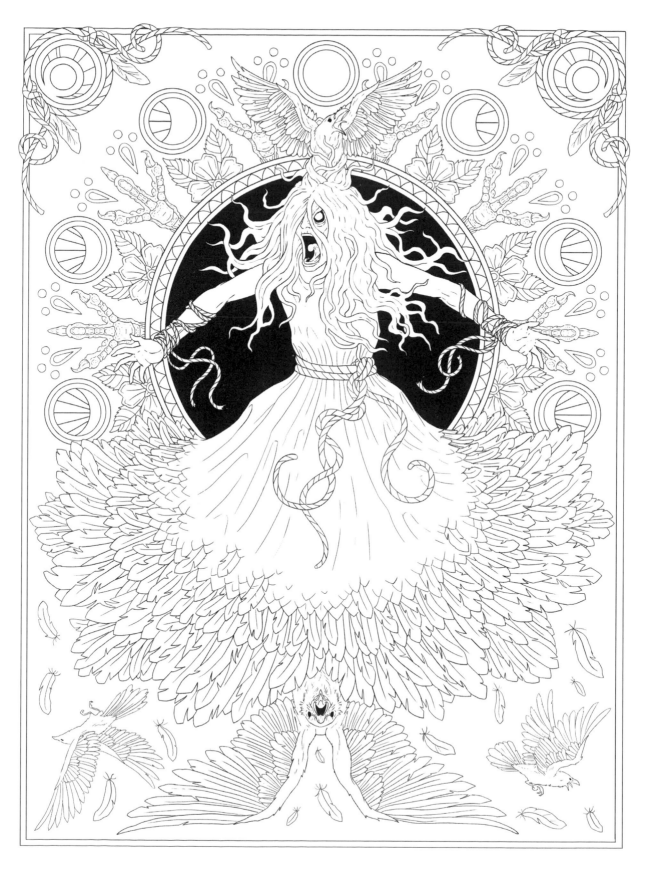

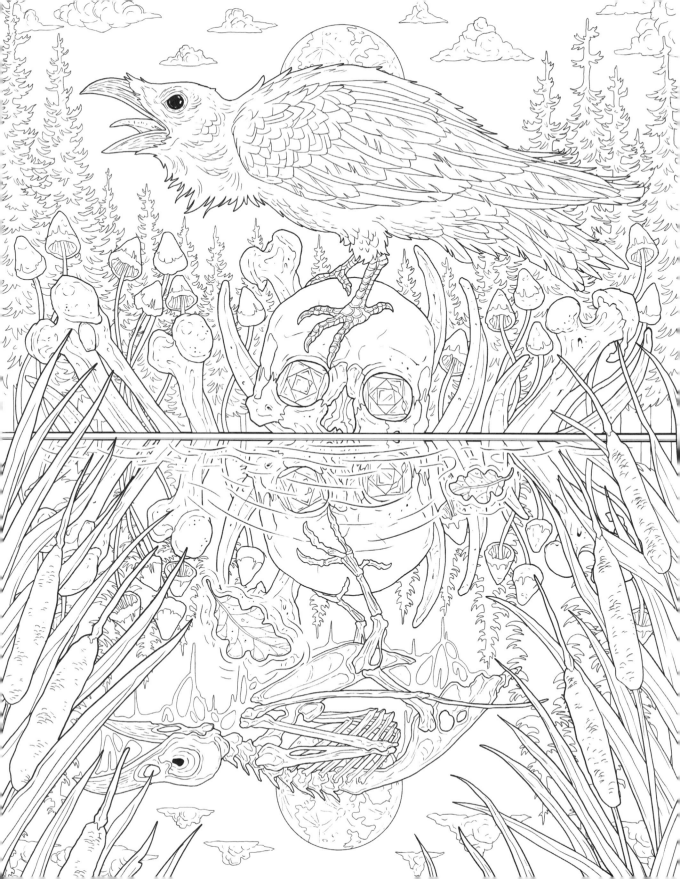

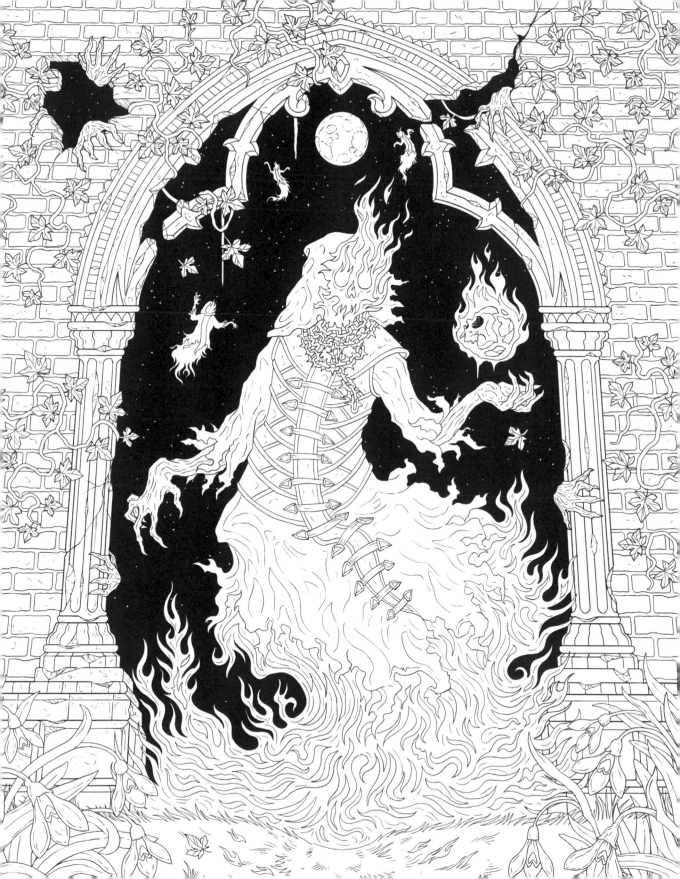

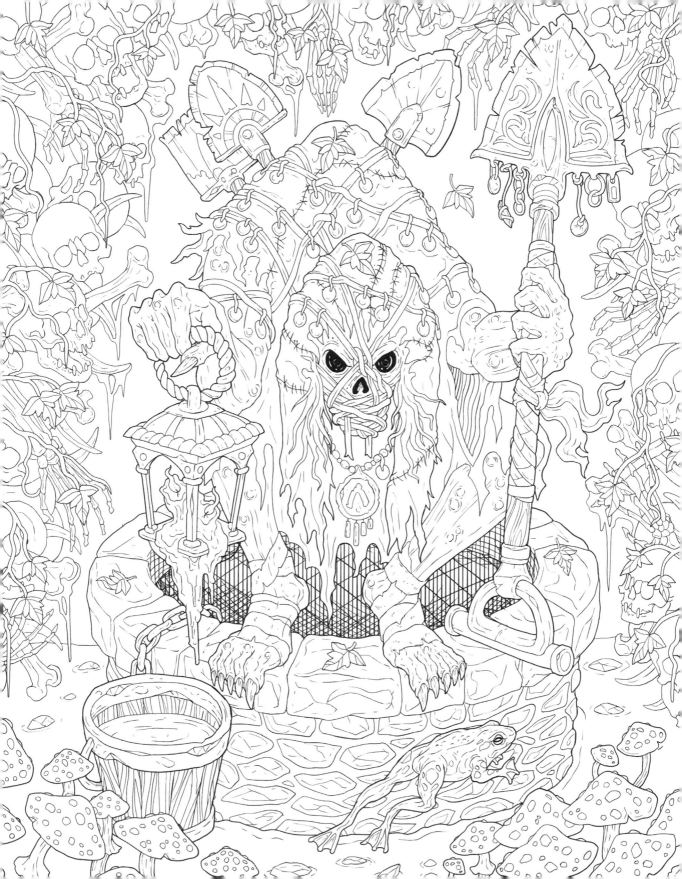

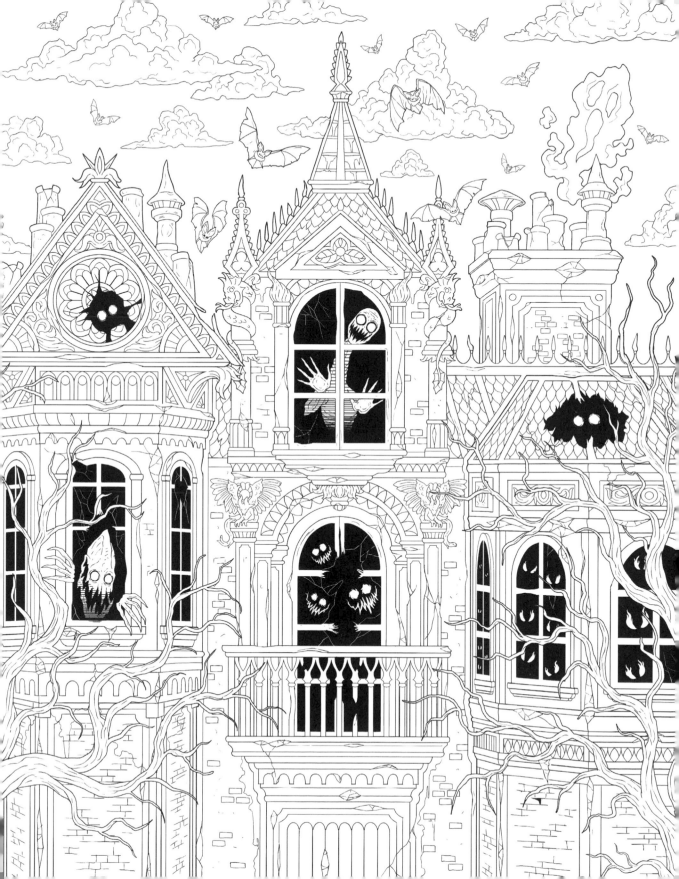

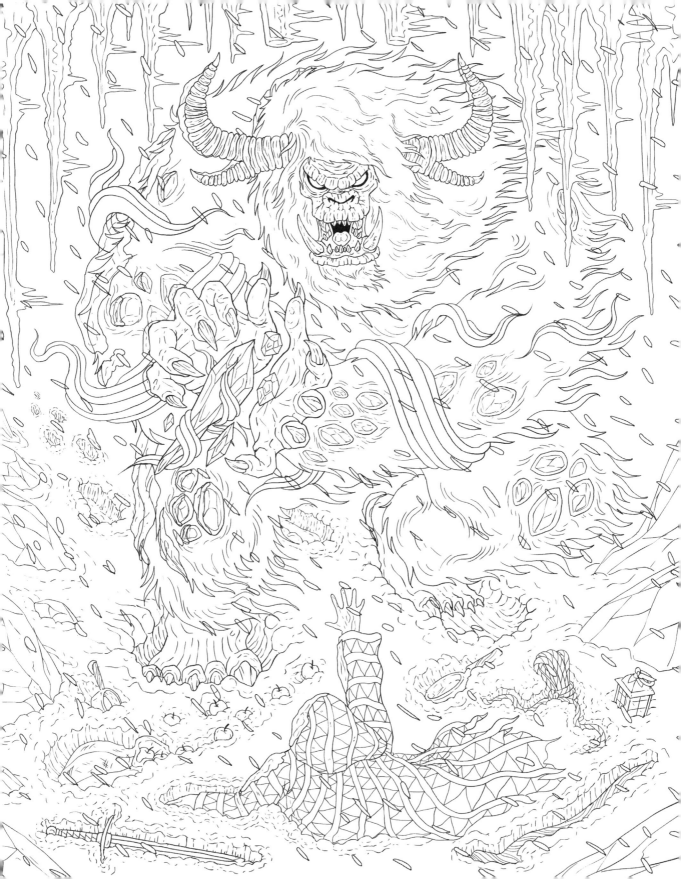

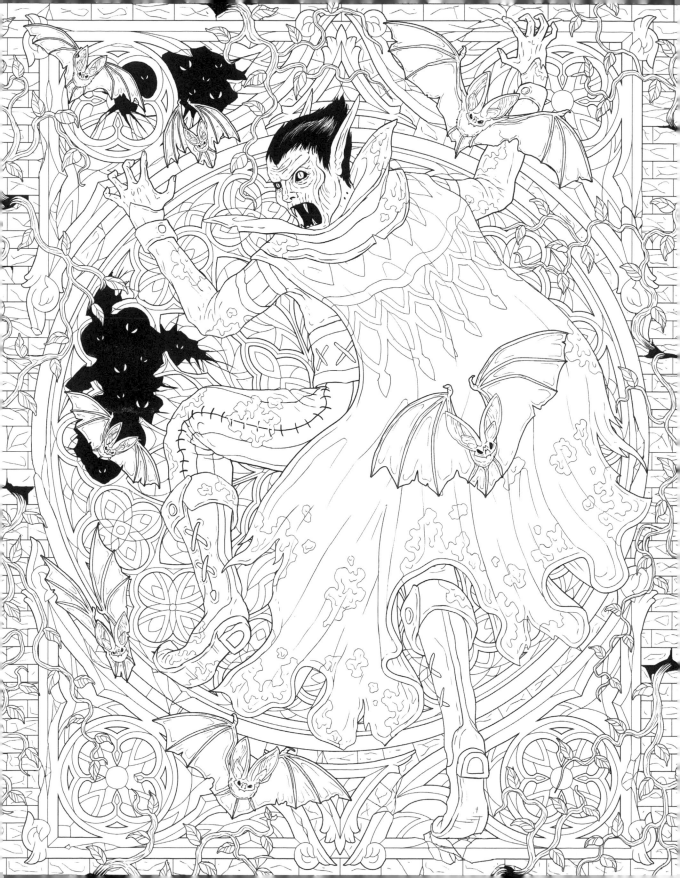

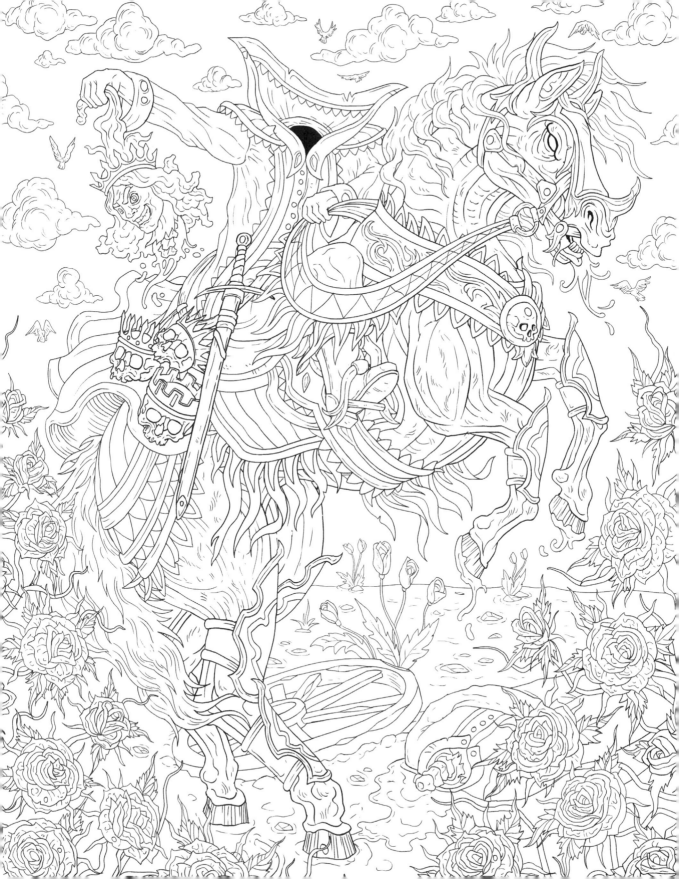

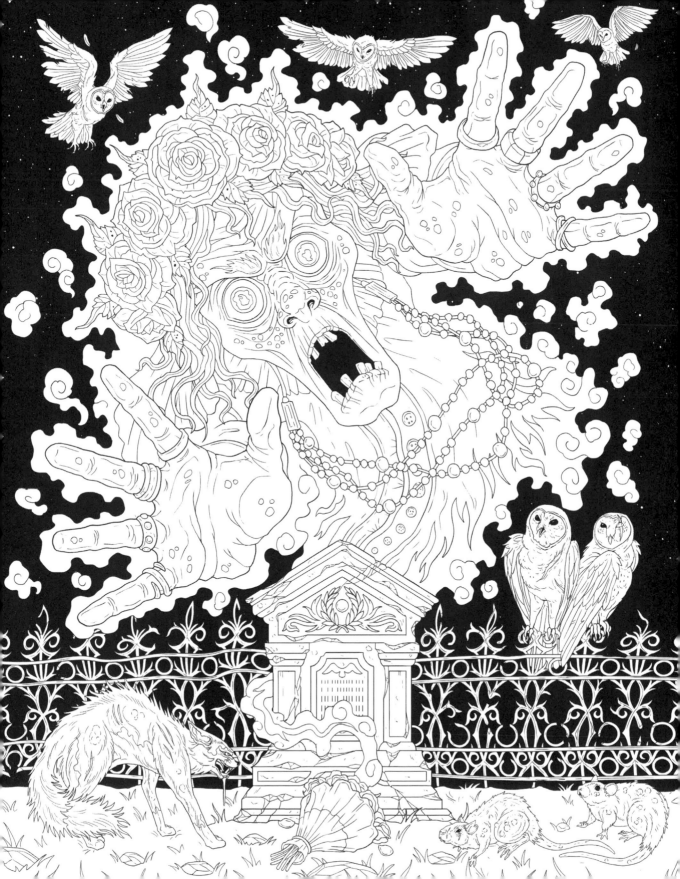

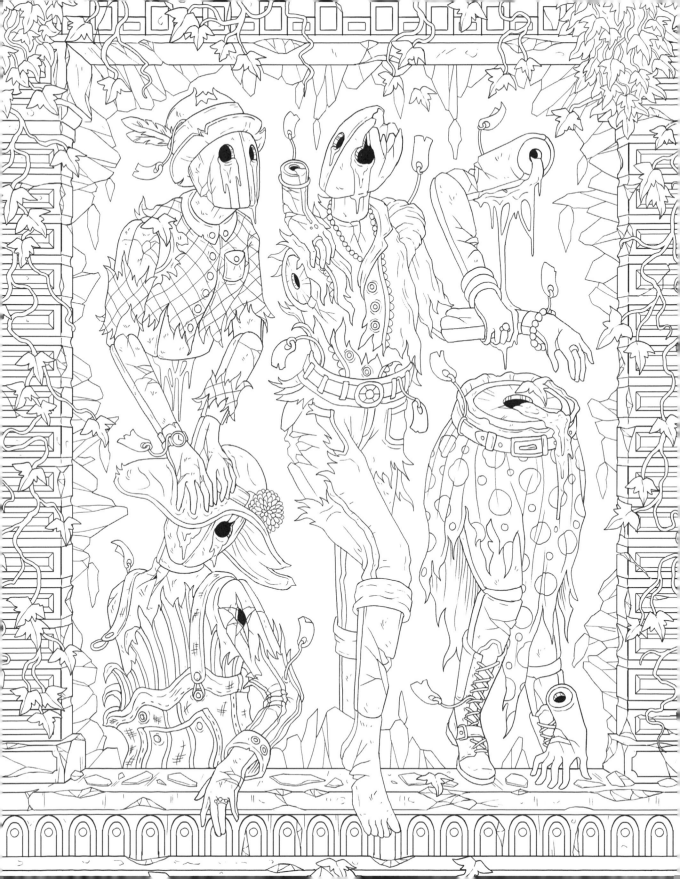

PLUME

An imprint of Penguin Random House LLC
penguinrandomhouse.com

W www.mombooks.com/lom
f Michael O'Mara Books
▶ OMaraBooks
O lomart.books

LIBRARY OF CONGRESS CATALOGING-IN-PUBLICATION DATA
has been applied for.

ISBN 9780593473405 (paperback)

Printed in the United States of America
1 3 5 7 9 10 8 6 4 2